The Woman in the Moon

☾

The Woman in the Moon

MARJORIE SAISER

The Backwaters Press

The Backwaters Press
1124 Pacific St. #8392
Omaha, NE 68108
402-452-4052

The Backwaters Press

Published 2018 by The Backwaters Press.

Saiser, Marjorie
 The woman in the moon / Marjorie Saiser.
 ISBN-10: 1-935218-47-6
 ISBN-13: 978-1-935218-47-0
 Library of Congress Control Number:
 2017946108

Front cover: Photo © Leonard Akert.

Printed in the United States of America.
First Edition

for Don, again

Contents

III **Crevice in the Universe**

I

Opening to
Some Other

☾

The Nobody Bird

I'm nobody! Who are you?
—Emily Dickinson

The woman leading the bird walk
is excited because she thinks
for a minute the bird
is one she doesn't have
on her life list
and then she says *Oh it's*
just a dickcissel.
I raise my binoculars
to bring the black throat patch
and dark eye
into the center of the circle.
I see how the dickcissel
clings to a stem
when he sings, how
he tilts his head back,
opens his throat.
The group follows
the leader to higher ground.
The wind comes up; white blossoms
of the elderberry dip and
right themselves in a rocking motion
again and again. An oriole
flies into the cottonwood,
the gray catbird into
the tossing ripening sumac.
The nobody bird
holds on,
holds on and sings.

I Notice Juxtaposition in America

A woman in a ball cap stands on 57th
holding her message
before her on a piece of cardboard,

but I drive on to Safeway
and make a beeline to the seafood aisle,
a display of fish, red snappers

next to three crabs,
faces pink and white,
emerging from shaved ice.

In the speakers a sad song:
Heartache tonight, a heartache tonight.
I notice the little dance it puts into my step.

At the checkout I read the covers of the tabloids:
DEEP AGENCY CUTS next to BUILD THE WALL,
and that's next to an oversized cookie

frosted to say: I LOVE MY MOM!
Mostly I keep thinking of the live lobsters
back in the seafood department,

pushing around in the tank, waving their pincers,
and there's that one that can't get away in any corner
from the other that won't quit climbing on.

Message on a Train that Crawls by at the Crossing

the words I can't decipher
the language I wish I knew
words sprayed on at night
dodging the watchman

the skill with an aerosol can
push ON, spray an arc, let up, spray again
big letters, obscure shapes
on the tank cars and box cars and caboose

the artists
working close to the dusty metal surface
at their particular location
their message to me
at sea in my own country

whose shoulders did they stand on
whose life were they fighting for
was it mine

In fat symbols
sharp daggers
it seems it could be yes it is
my name
or your name
gaining speed
rolling out of town
in a script we don't know
and have so little time to learn.

Choosing a Tattoo

I want the tender field of skin
over the flat of my shoulder blade
to bear a lily
I'll show to a lover in lamplight.
But it is mostly for myself
I invite this flower to my back,
this image I will carry. Not tentative,
not temporary, not maybe.
All my life I've been *maybe*,
now I lie facedown
on a table in an inkshop, an offering
beneath the needle,
this pain while *maybe* becomes *lily*,
pricked and stippled and stemmed,
its throat
an icon of the scream—
or song—I never allowed myself.
I'll see this lily only in a mirror
but I'll feel its petal
spiraling, widening. I'll feel its
question mark and I don't know yet
whether it's a hand raised to volunteer
or a fist flaring in defiance.

I Believe in the Dog

I want him to love
the one who confines,

who keeps walls around him.
He has to stay home

until the wanderer
returns, expecting him to wag

like it's some glad morning.
I believe in the brown in his eyes;

I name it trust,
kneel to the dog,

lay my face on his fur.
Will you not love your captor,

your head in my hands,
my breath so close to your own?

Her Brown Horse Must Rise from the Dead

She wants him to rise from the floor of his stall,
Snazzy who peppered his delicate hooves
across the corral every cold morning,
kicking the kinks out. He must rise
as if from deep water.
What is a day worth
without that brown horse? Oh loss,
and from the wind not a single sigh
of grief. He's still her horse.
He trots up to her,
warm apples of his breath
on the skin of her face,
her get-ready hands
on either side of his skull.
She lays her cheek water-streaked
on his face. I am wrong. I am wrong.
Someone tell her
her beloved is gone.
She will wear that cowboy shirt
I gave her. On good days she wears it,
snaps its snaps over her belly,
brush teeth splash water pour coffee drink some.
Wasn't the moon on its back last night and
didn't I show it my closed fist?
Moon, old yellow trick of looking empty.
Every day is like this like this.
Didn't I show it my closed fist?
After great pain like this like this.
Didn't I show it my closed fist?

Crane Migration, Platte River

I am in danger of forgetting the cranes,
their black wavering lines in the sky,
how they arrived as if from the past,
as if of one mind,
wheeling, swirling over the river.
I am in danger of losing
the purling sound they make,
and the motion of their long wings.
We had stopped the car on the river road
and got out, you and I,
the wind intermittent in our faces
as if it too came from a distant place,
wavered, gusted.
Line after line of cranes
out of the horizon,
sliding overhead.
Voices of cranes
strange, rousing.
Something old in me answered.
What did it say? Maybe it said *Kneel*.
I almost forgot the ancient sound,
back in time, back, and back.
The road, the two of us at the guardrail,
straggle of weeds flattening and rising
in wind. This is what I must retain:
my knees hit the damp sand of the roadside.
You knelt too. The birds landed on the sandbars
as night came on, and we were wordless together.

My Love with His Saw Has Taken the Cedar Down

I am standing on the stump
where the tree had stood
when he comes around the corner,
sees me motionless, staring,

and asks "Is anything wrong?"
Nothing is wrong.
Everything reaches the end,
aromatic or not,
unmarked or not,
nothing lasts forever,
and it's time for the cedar to go.
It stood all those nights,
all those one o'clocks, two o'clocks,
under the moons I never got up to look at.
The cedar a few thousand nights in the wind
a few feet from where we lay,
he and I, separately dreaming,

or one awake,
listening to the other, breathing.
The cedar he climbed every December
in boots and gloves
when he put up the Christmas lights,
using the limbs, their parallel pattern,
for a ladder to reach the roof.
The cedar was there
hanging on in dry times,
its roots making very small

steady progress
and its molecules lining up densely
purple and deep red and white.
When the tree is opened,
as it is now,
its colors surprising and stark,
out into the air spills
a faint comfort that, like moonlight,
will not quite fade.

A Room in New York

—Painting by Edward Hopper

The piano, the woman
not playing it, and a man
reading his paper. A distance is
there, mighty distance
between two who love. Didn't one's
mouth once, breathless, willing,
travel the hills of the other's body?
The lovers inhabit the yellow room and do not
kiss. One of them has said something,
the paint does not say
what, but it keeps them together
and not touching.
The hands of the man will
hold the newspaper open. He
will not look at the woman, though
they have lain close and warm.
Their distance will place you
just outside their window, floating
above the street, looking in.

The Dorothys

I want to be like those women who served.
I want to but I can't. I am throwing
their fine ideals, their self-sacrifice
out with the bathwater.
Dorothy Wordsworth
clapped the mud off William's shoes
and went in to fix his leg of lamb.
Dorothy Shakespeare, if there was one,
stayed home in the nether regions
while William walked around London
eating crumpets and drinking ale
in interesting establishments along the Thames.
Everybody has to look into the mirror
once in a while and see who
really stares back. In my case
it's a wild creature
who wants to put one word
next to another to see what happens,
see what comes of dropping *chicken*
in next to *splinter*
and *lilac* next to *nipple,*
pickle next to *member,*
tap the words down
into the slots I have for them,
stand back and enjoy.
Maybe Dorothy, whether Wordsworth
or Shakespeare,
clapped his mud-caked shoes,
the sole of one

on the sole of the other,
watched the clods fly helter-skelter
and then maybe (I'm hoping),
she would once in a while
call into the interior of the house
to tell the William there:
I'm taking some time off, I'm gone,
I'm alive, today is sunny, tomorrow
who knows? You can eat cold
kidney pie or starve.

Gratis

At the neighborhood give-away
a few plants in paper cups

almost falling over.
I took two home,

planted them. They made it. They bloom.
Red petals atop a wand,

they wave, they bob.
So many things I haven't earned.

You still love me, you
in pajamas, making coffee.

A jay in the locust calls *Thief. Thief.*
Yes, I answer, I'll have it all.

There's a Door in this World

I don't mean the patio door,
open at midnight,
admitting the air
which has been waiting under stars.
I mean an opening to some other
existence nobody has any words for.
I roll the door back and stand barefoot,
unlighted, the cool breeze nosing in,
licking around my face and arms.
My work is to stand
on this X where I am,
minding my own business
which at the moment
is noticing the silhouette
the palm tree makes,
surmising where the dove is,
where the owl is, what doors they are,
what door I may be.

Suddenly, So Suddenly

Tonight walking in the arroyo
I hear crickets
and then coyotes.
There's Cassiopeia, sailing high;
there's Sirius
looking as good as ever, brighter even.
When the dogs take up
barking at the coyotes, suddenly,
so suddenly, I'm at the door of old age.
But it's only the white pine
where I saw the owl this morning.
Surely the bird sits on a limb in the dark,
surely it inhabits airiness.
Even if I shine my flashlight, flash it around,
lighting needles, branches,
I can't quite make out the shape.
It might be here next time,
upright, in no hurry,
its deep bright black eyes
taking in everything about me.

As If I'm Going to Live a Hundred Years

I fritter hours, drop them like nickels
from a pack slung over my shoulder,
ever getting lighter. My mother died trying
to tell me something, thrashing about
in her bed, some message I wish I had.
Tonight I walk the arroyo; the rabbit
skitters out of a clump of brittlebush.
I'd never notice, but he flashes
his white tail. The light is going
as it went for my mother. *Wait.*
Whistle of the curved bill thrasher,
not wanting to give up on the day.
Wait, wait, she whistles. And I do.
She's called up one star,
one lone pinhole in the west.
The owl chases after it,
wings shaking out a silence.
I have much to do before morning.

II

What Would
Flourish
Above the
Surface

☾

If I Carry My Father

I hope it is a little more
than color of hair
or the dimple or cheekbones
if he's ever here in the space I inhabit
the room I walk in
the boundaries and peripheries
I hope it's some kindness he believed in
living on in cell or bone
maybe some word or action
will float close to the surface
within my reach
some good will rise when I need it
a hard dense insoluble shard
will show up
and carry on.

What He Needed

I told him about a study
that showed pain was relieved
by laughter to be more specific by
belly laughs it was a stupid
idea but I was desperate and
that's what the article said
he was in so much pain I wanted
to help him if I could I told him
some people reported a few
hours of good sleep after
laughing really hard there was a ratio
number of minutes laughing
to number of minutes they could sleep
he could have said any number of things he
could have said you have no inkling
no fraction of an idea about pain
so bad you wish you were dead
he had in fact stopped eating
he had in fact decided to escape
the tubes in his arm his tag-along
monitor ticking like a Martian
and to go home to his green recliner
his north window his black and white dog
to be more specific he said will you
help me he said will you get my shoes
he said that right before I betrayed him
to a nurse to tell the truth I was afraid
an impossible coward I had never before
lied to him but I made as if I were going to
get his shoes those brown dress shoes he had worn

to the hospital those which he had pushed his feet
into and leaned over in old man pain and tied
I couldn't I was the turncoat
the enemy had brainwashed and I turned him in
told the young nurse intent on her computer
she rose up and went to his room and I
came at her heels traitor-like his one last
chance to walk out on two legs
when in fact he needed a buddy he
needed a daughter he needed his shoes.

When I Tell You

When I tell you I'm from the banks of the Niobrara
ask me if the wind was cold
or kind
blowing over the stubble of the corn field

ask me if it stopped when it came
to my bedroom window

ask me if I left town
and how it is that when I go back
I am the outsider

When I tell you I can bake an apple pie
ask me if it's for Reuben
ask me if I bring a slice to him
and watch him eat

When I tell you I love birds
ask me why a cardinal is my father

ask me about the pheasant
the little cough it gives
when it's hiding in the tall grass in the morning

ask me what the cranes mean
when they swirl in thousands above the river
as the sun goes down

When I tell you I dream of long hallways, of being lost
and no doors will open
ask me what helps me find myself

ask me about the Milky Way on a moonless night
ask me about that spill of stars
ask me to name the ones I know

ask me to stand still
and listen.

My Mother the Child

She didn't get her hand stuck
and chopped off in the corn picker;
she didn't make headlines that way
but there must have been
a day something happened
to the unmarked child she was,
something I can't reach back
and save her from,
and it, or he,
got her,
wrung her turtle-dove heart
or filled her mouth and eyes
with fear, which drained away
of course but which also
settled, like water
in the aquifer, to influence
what would flourish above the surface
in the rows:
cabbages big as washtubs,
radishes waiting to be pulled up by the tops,
onions sweet as apples, and yet something
sometimes shriveled the pears on the tree.
An oriole moved among the empty branches.

I Learned from Her

Tell a lie and then believe it
Don't talk to your sister for years
Drink coffee all day
Don't buy fancy clothes
Don't compliment anybody; they'll get the big head
Don't trust the bank, the church, the post office
If you think you might forget where you
stashed this or that, write yourself a note in
shorthand; nobody knows shorthand much anymore
Read the newspaper, keep tabs
Do the crossword in ink
Don't say what you are thinking
Don't say what you are thinking
Don't say what you are thinking
Don't buy bananas at Martin's Grocery
Don't forget what you think your friend said
don't ever check it out to see what she meant
Love your daughter so much all your life; she will
know it someday after you are dead.

She Went to the Fair

In the maze and glitz and commerce of the fair
she tried to be good company,
like any girlfriend of her era, interesting, interested,
and mostly succeeded, followed my father
around, saw what he looked at.
She didn't have to fake it at the draft horse competition,
enthusiasm for the way a Percheron can
move, stretch out, reach forward,
arched neck, flared nostril, a ton of grace.
An animal kept indoors,
small stall, wooden walls to doze against,
but then on command, for the judge,
run—
float for a moment, haunch and hoof,
over the manicured dust of the arena,
over the captive life.

Final Shirt

After my father died, my mother
and my sisters picked the shirt, the tie;
he had just the one suit.
I left them to it, I didn't
want to choose, I loved him
all those years. They took a shirt
from the closet, I don't remember
which one, I'm sure he had worn it
to church and hung it up again.
They held a tie against the cloth
of the shirt. They decided, finally.
It's like that. Things come down
to the pale blue or the white,
or some other. Someone buttoned it
over him, those buttons he had unbuttoned.

I Put Off Apology, Mother

We are innocents, both of us, now
in separate worlds: you beyond
apology. But I offer remorse anyway

into the wind blowing tonight
relentless, tearing at the citrus tree.
It is heavy with green fruit, Mother,

and will crack. Stop
shaking and pushing further than
wood can stand. Stop whipping

my hair out long before me,
streaming it back behind me,
ruffling it into my face. What anger

you had and could not act. Hair pulled
back, beaten down on the skull,
foolish girl, bad, shameful child.

The wind beats my hair, changes,
grabs me, would, if it had arms,
hold me against its old, thin ribs.

I Don't Know Which River I Am

Where the Niobrara and the Keya Paha join,
where one flows into the other
and the new is neither,
that's me, all my life,
not quite this,
not exactly that.
Tolerance my father had
in abundance;
he could forgive.
That water merged with bitter
because my mother
knew everybody had wronged her.
I'm confluence itself.
I want to be kind; I want to be right.
Look out for me.
I'll run you over in the road
but then I'll brake
and get out of my car,
leave the door hanging open,
run back,
and hand you the keys.

We Searched Her House for Money

There was none
or someone found it
before we did.
Wads of cash
in a coffee can,
the rumor had it.
My sisters and I
searched the basement;
there was a stack of left-over lumber
she might need for
something, a soft dust
over the shoulders
of the jars she hadn't
filled with fruit,
a pile of worn-out jeans
folded, ready if she needed them
for patching. Small boxes of nails,
crooked or straight, waiting
for their project. Upstairs,
each drawer and cupboard
we opened and pawed. We were
on a mission, swimming around
inside the sunken ship she left us,
divers wearing tanks,
carrying lights, staying long enough
to ascertain, swimming off, up.

Her books, photos,
her stash of copper bottom pots,
her forks. We carried
some piece away
to place in our own vessels,
the bits and particles
we gather to surround us.

Hamburgers, Frying

She mashed each patty into size and flopped it
into a cast iron skillet where it had to

behave and shoulder up to its buddies
without trying to be sirloin. She assigned motives

as if she knew what people were thinking,
no court of appeals. She salted and peppered,

had the buns ready, one big leaf of iceberg lettuce
for each, two pickles. She was lanky

instead of dainty, Irish instead of Hollywood.
Having said all this, I must also say

she was gorgeous and troubled and not boring.
Some people liked her and I am now

one of them. Sometimes I stand
at the window, hands on hips,

as she did,
to look toward where I cannot go.

She Didn't Want Another Dog

You get attached, she said,
and then they die.
Too hard, the leaving. She left me
and the leaving was hard. The dog,
expecting his due, jumps off the couch,
comes to my chair.
What a sparkle of waterfall he is,
stretch and shiver and wag,
and what can I do
but rub his head
and neck and down his spine.
His ancestor began to be with my kind
around a fire. He added
not one twig to the flame.
The bones under the slippery
hide, their configuration,
linkage. He's caught
by the hand rubbing his skull.
The animal and I: eye contact,
as if choosing
this easily broken world.

When She Died

where was I but
on a chair beside her in the room,
my mother thrashing in her bed,
the nurses busy in the lighted hall.

Long ago another hospital
I came, ready, down
the birth canal
wedged, squeezed
about to begin my life in air
I slid out
and came to a stop
in someone's gloved hands.

My mother died
a long way from that,
gasping as if
she too traveled a tunnel
her last air
surprised, angry
but breaking through,
breaking out.

Despair Woke Me

Despair woke me in the night,
the yard quiet, moon not yet risen,
trees and sky waiting. I looked for
the stars I knew, not many, naming some
to comfort myself: little
Rigel, red Antares, fuzzy Polaris,
though each could already be a cinder or
burning at such a distance as never to warm me,
and I happened to think of her
as if to bring up from the horizon
what she said one day in particular,
at the door to a very plain room
long ago disassembled,
existing nowhere anymore.
A small set of words, each following each,
to make me smile in the dark.

This Is Her Territory, Not Mine

I return to my mother's childhood,
the big yard in front of the farmhouse

where from windows of the second story
she might have seen me, her future,

standing in mittens and a coat
and I, looking up, might have seen her

shadow behind the white curtain.
It would soon be evening, it was winter,

she was young. Someone had sent her
upstairs to the unheated room

where vegetables were stored
in sand-filled crocks along the walls,

told her: *Get one turnip, three carrots.
Make it snappy.* She pauses

at the window,
her small hand

moving the curtain aside
to look down at me in the yard, waiting.

Unplanned gesture,
then back to her errand. Digging

into cold sand for what is stored there,
bringing up the root crop, her rich unadorned life.

III

Crevice
in the
Universe

☾

Because I Am So Lonely

I stay in bed a little longer,
the lamp directs a cone of loneliness
onto the carpet (it gives and
continues to give), the door stands open
and the hall is lonely, showing
a rectangular way out.
The closet is lonely,
all its shoulders flat and headless,
the pile of books on the floor
spilling loneliness.
I have an abundance of it;
I will feast today
and pick my teeth after
and say "Wasn't that good?"

The Woman in the Moon

The woman in the moon
has full cheeks, has dimples,
is fat when she's fat,
like tonight. She
thins down from time to time,
doesn't worry about it,
the woman in the moon. Tonight
on the prairie we stand in a circle
as big as it needs to be.
My right hand holds the hand
of a child I don't know.
My left hand holds the hand
of my old friend. The lines in our faces
could almost be beautiful.
We dance, not too complicated,
a shuffle really,
and then we let go and walk to the cars.
I see the child has broken away now
from his father's hand.
It's a game, he wants to be caught,
his father catches him.
How exquisite the world is!
And the woman in the moon.
I roll down the windows of my car,
drive a little too fast. There is the smell of grass.
When I stop at the first light on the edge of town,
I hear one cricket
out there somewhere.
The woman in the moon
likes me, looks me in the eye,

floats above the road.
The road is straight
and it leads home. By the time
I reach the four corners of my house,
the woman in the moon
has risen high. She has paled
and doesn't mind that she has
put her gold away.

Of My Ancestors I Know This

A little of their scarves, their home-sewn
underwear, their first spots of
menstrual blood, their yearnings
for a long-eared puppy

or some other foolishness,
the lack of a pencil for
homework after chores,
the scolding for spilled

milk on the floor. The thin old
strong woman who loved me,
who mailed to me from her city
a taped-up cardboard box

holding two blue glass
swans, how did she know
to send me birds? I see her
in Kresge's, standing in a paisley dress,

looking at a row of figurines,
her hand picking up a swan,
her fingers tracing,
as mine would trace,

curve of neck,
cool unyielding surface
of the closed wing.

Today I Write My Son

I tell him about the quilts I'm going to
leave him, those burdens
people pass on like DNA, with apology

for the bother. I had wanted to give him
useful things, which these are
and are not, like stubbornness

and the ability to squeeze a nickel,
the need to be secretive. My mother
sewed that as sure as white thread

along the patches. It's in the pattern; it
is the pattern.
My son, there are patterns I break,

telling you where the money is
and how the will stands. Before
the expanse of quilt, there's the cutting

into squares, laying edges
together, there's stitch after stitch. Still
subject to tear, but here's the whole

as I've pieced it,
my hand to yours, yours to hand on.

My Daughter Tells Me She Loves Me

It's after I make a big mistake
(again) trying to be helpful.
It's that she will have to negotiate traffic
the squirrely intersections
to deliver what I forgot.
It's late, it's hot, the back lot
of a motel, where I'm waiting
in my robe and pajamas
for her, for the hand-off. I'm
waiting near the overflowing dumpsters
a game of dodge ball going on
in dim light, parked cars
shouts of children
it's what I can't fix
and can only tangle further
it's what can fix it
she gets out of her white car,
leaves the door hanging open
there isn't time there isn't
time but she says it,
the only thing there is time for
in the bone-tired heat and sweat of July
I love you Mom
the tangle the knot
it really is all right.

Cardinal/Deer

The cardinal is my father
though he was not so colorful.
Or was he?
Let me tell my daughter:
Be as scarlet as you like.
My father is also the deer,
standing on the lip of the forest,
melting into shade without a word.
He reappears
leaping, landing, leaping.
These two messengers: the bird, the deer,
one bold, one quiet.
Let us, too, be double, my daughter.
Send out a song.
And also, silent,
glide over the ground, over the fences.

What Did You Think Love Would Be?

When you pushed him out into air
or rather your body did it all
by itself, as it had formed him
a seed in its pod, complete,
sleeping mostly, sometimes
the perfect jeweler's hammer
of his foot against the womb
and you could feel that language,
the soft notes which
his heels had for words. And
today he has his own work to do,
the hours, the papers and screens
to fill with symbols,
once in a while a message
you to him, him to you:
weather, schedules, taps
against the wall. Perhaps
love is a canvas, syllables
brush strokes, spots of color
in the whole, and you can
pick them out, can see them,
their particular hue among the many:
here and *here* and *here*.

After My Conversation with
the Troubled Woman

After my conversation
with the troubled woman,
birds still move about
through the cool air
over the rooftops.
Clearly she was not well,
clearly she chose me
to listen
about the evil man
at the Ford garage
and how the good
book says our inside
should match our outside
and his doesn't.
The world so sinful
including that jezebel
her son went off and married.
What was I
supposed to do?
I don't know.
Red bird no longer singing.
One eye lying against the dirt,
one eye aimed at the cloudless blue
it has fallen from.

I Let the Ridiculous in Me

I let the ridiculous in me
prattle on. I sounded stranger
than I am. I need to feed my intelligence
a lot of silence, a pond in moonlight,
the wind dying down
after bothering the surface,
but I gave the microphone
to the worried woman
who inhabits me. She grabs and gabs;
well, she lives here too. But look how
happy she is when I give her something
to do. She cracks walnuts for an hour,
picks out the tasty pieces, puts the shells
into the trash. She listens for the white-crowned
sparrow passing through. Her hands busy,
she doesn't need to impress.

Therapeutic Touch

An RN is teaching us Therapeutic Touch,
about which, she says, be as skeptical as you like,
it won't matter, she says, you'll see.

In the luck of the draw, I'm paired with someone named Scott.
Scott's the kind who at the beginning of class
was embarrassed when he knocked over his paper cup,
a dark spill spreading on the carpet under his chair,
but here he is, ready for anything,

facing front, sitting like an Egyptian statue,
and I'm following the teacher's directions.
Stand behind his chair, she says.

I'm looking down into his short haircut,
some gray, some black. I hold my palms
a few inches above the top of his head, as directed,
move my hands slowly, smoothing air
as if sculpting, not quite touching
the shape of his head, his neck and shoulders,
his denim shirt and collar,

smoothing the air above the hair on his arms,
over and over softly
elbow to wrist
and out to the tips of his square white fingers,
very slow very close.
Now, she says, his knees to his ankles

and fan out over his shoes.
Scott's Reeboks, I notice, are new.
The ties, the spotless stitching.
Now this time, the teacher says,
touch his forehead
your fingers lightly and slowly across it.

Lightly
just barely
his forehead.

Scott has closed his eyes as directed.
Go ahead, the teacher says, and touch his eyelids.
I'm skimming Scott's eyelids,
the nerves of the tips of my fingers
across the soft skin of a stranger's eyes.
Well, Scott, I want to tell him,
it's been that kind of day. This morning
alone in my kitchen
I danced to music on the radio.
I raised my empty arms and danced with my ex-in-laws,
those relatives I married into and divorced from,
those old farmers who knew how to polka.

Strange the ways we have of mourning:
lively music, quick turns.
I wept then, dancing,

but not now. Now I'm circumspect with my stranger,
I follow directions. Thin soft skin of the eyelids,
even the color soft,
a pale purple near the corner.
Scott, it's been that kind of day,

my daughter calling early to tell me her son
is ill. So I imagine the boy now here in your lap—
why not?—this is what dancing and touching a stranger can do:

a boy's knees drawn up as if to
fit his bony body into the space available,
his white arms folded,
his feverish head bowed, his eyes closed.
Rest easy, child—what's a few thousand miles?
Draw in
breath after breath,

rest now
against the world that loves you,
breathe easy,
get well.

In the Dark Times, Will There Be Singing?

In the dark times
Will there also be singing?
—Bertolt Brecht

Desert morning, the coyotes return
to their cubbyholes, the stars
have wheeled in arcs

to stand in their appointed doorways.
The great horned owl on the light pole
sees the neighborhood, sees, if he wants to,

how I stand shoeless on the cool sand,
lucky cuss, wingless bird that I am.

In the dark times there will be singing
and I, in a forgotten crevice in the universe,
will spread my arms and inhale deep, enormous.

What I Think My Real Self Likes

She likes to stand in left field
on a day with no ball game,
only crows on thousands of blades of grass.

She likes—I think she likes—
a park at midnight,
clouds trailing over the cheeks of the moon,

showing the light, hiding it.
That kind of flirting she likes.
She grabs my to-do list

from the counter and beats me with it.
Stop making this crappy fuss,
she says, and stomps off

in her red leather boots.
I hate the sound of it, you know
what I mean: the quiet
after she slams the door.

About that Smart Thinly Veiled Stuff

That smart thinly veiled stuff
I said to my daughter—
my admiration was real as eggs in the nest
but my goal was to save her.
I wonder if my mother, too, had that intent.
Let me, in the time I have left,
love my daughter
and keep my hands off.
Let me say a simple thing
and mean a simple thing.
Let a word be a round pebble
passed from one hand to another,
a little weight in the palm,
not a burden, not a door,
not a justification,
not advice covered up
with a blue scarf.
Let me love her as a bird might
value the tree and the rain.

My Legs Were Smooth and Bare

My legs were smooth and bare
when we stood for a nanosecond

in splendor we didn't know we had,
an ordinary day, a pause in some summer

game we played, balls we chased and threw.
Somebody snapped a picture, and then

we went on getting old, the spine
settling, the bones gram by gram lighter,

slight sag of skin, of eyelid. We can't go
back, lovely animals that we were,

so we must stumble forward.

Ah, Charles, If You Could Have

C.C. 1967–1987

If you could be in the known world
this morning, peeling this orange,

the cover of it giving way in pieces.
The aroma, Charles, the tang,

even the color of the thin rind. I wish
you had felt it was worth it,

my good, my handsome, my clean-cut boy.
I know I can't know

how unbearable the days became,
the nights, tearing along lines unseen.

The sweet, the sharp, can't they
on occasion reach across a gap?

Won't some small common thing
sometimes keep us here?

Green Ash

I took a place, rooted
where I found myself

and rose, steady with rain and sun
and rain again. There were machines

but I did not look toward them,
faced sky with its cloud shapes,

drew up water until it flowed
in every vein and twig, I made

green of it, let birds build, come and
go, as if they were my only voice.

I gestured, waved, moved
with midnight storms, felt tall,

kept going, knuckle of new branches.
I held snow, dropped it,

reached up and out. This is gone now.
In concentric rings I remember.

I Meant to Be

I meant to be as kind as kindness
itself had shown me. I meant
to cook, shiny rapid blade

against the block, hand
above the boiling soup.
I meant to share, to ladle into bowls

without counting or accounting, I meant
for yellow roses to grow by my gate,
I meant my door to be heavy carved

oak on big hinges, swinging open,
but this woman
or that woman

annoys me, the one I should
study. Last night I woke to a noise
on the rocks under my window,

a scraping, a pause, more scraping.
Something drags
the heavy chain, the bad leg, the burden.

I will keep on.

Each Wrong Choice Was
a Horse I Saddled

I rode a little way down the road, got off,
and saddled another,

got better at saddling,
faster at getting on board.

Some of my best days, like today,
all I can do is hang on,

the animal beneath me
galloping in some direction I can't

fathom, my eyes shut,
my rag-doll body flopping,

no stirrups, no reins,
my fingers in the mane,

my most recent egregious error
trying so hard to buck me off.

Even If I Have No Time Left

Let's say for the sake of argument
I have no time left in the spool
too much of it used
on TV shows eating crackers and cheese
that long stretch I wasted caring
what some people think
let's say I'm down to the blue-edged paper
that marks the last of the roll
what shall I do with today
I'll still make a pot of tea or a tequila
sunrise I'll sit down with you to say
nothing or nothing great I might ask
What's the weather in Omaha
and you might say Wait I'll look it up.

Smoke from Kansas

Air is hazy over my town:
fog, vapor, particles.
The newspaper says

I'm taking in particles
from Kansas. I can't help
breathing (I must) freckles

that rose up from flames,
from beige stalks burning.
Think of the red of it, the black,

fire rolling across dry prairie, think of
the noise fire makes as it eats.
The shimmer above what is changing,

gone, turned loose,
coming down toward my backyard chair
and I draw iotas in. I become

Kansas. I've always been Kansas
and all those others. I am them.

My Notes in Margins

My notes in margins,
along the edges of the text,
the ink I've left. Who

did I do that for?
Myself. Only myself. As if to say
you will live long enough

to read this page again
and you'll see what you
marveled at then

and compare it to
how you feel now.
The dust of the comet's

tail coming around in
orbit again. An intersection.
What was

meets what is, and,
for a second,
shines.

When I'm Reading Late

When I lean my head back
to rest, I notice
the words that remain
on the back of my eyes.
Lines of letters stretch out,
superimposed for a moment
on what's in front of me.
In that way, you too
are present daily:
you, running your hand through your hair,
you, clearing your throat.
Yesterday I went about the business of living,
today again the talking, the give and take.
I don't think of you; I don't have to.
Behind what I say to the world
is what I'm thinking,
and behind that, like shadows on the retina,
you show up, you hang around, you quietly dissolve.

Dust Storm

Dust so thick
we can't see the mountains,
that row of buddies
standing like our grandfathers,
called up to go to war
in their khaki uniforms.
They chose service
or it was chosen for them
or they did not run away.
Their families said they were
in service. Everything that meant.
What will our country be
after the dust settles?
What is it now? The air holding
each little lie,
a million particles
between us and the mountain,
suspended all night between
the people and the stars.

I Want More than I Should

I want a guarantee the pain
means nothing, and the symptoms.
I'm not done learning, I want to last
past my time—doesn't everybody?
I want to make art of it,
to have it and to eat it.
Let me paint
fire licking and falling back.
Everything passes into flame
the sunrise the tree
even the mountain is eaten
by the machines of the mine.
I am small.
Let me rise
like the hummingbird,
pause mid-air,
and slide off with exuberance
on my invisible path
to the next red flower.

Going Through a Box of Old Papers

It's labor of a certain kind: touch,
open, skim, decide.
Soon I'll throw away
the whole lot, turn
the box upside down
like a chest of tea
into Boston Harbor
as our teachers told us
the rebels did, dried flecks
floating a bit before sinking
in defiance of authority. I toss
the folds of a letter, important,
like the last kiss it was.
It leaves my hand with
the small sound paper makes.
I am lighter now though I've
taken on the weight of what
I'd forgotten.
This is good work:
watching something fall.

Looking for Lady Freedom

i am looking for Lady Freedom
as you may be looking for Lady Freedom
she is no statue on top the Capitol
she has the robes of the homeless
i think i saw her you saw her
at an intersection in America
she was a man she was a woman
the soup kitchen fed her today
she is looking for a job
you or i behind the wheel
come up to the intersection
and Lady Freedom is there
but we don't know where
to rest our eyes go ahead admit it
i want the light to change
i want to pass by and get away.

What I Almost Say to My
Sometimes Friend

There are people
to take your mind off
your current trouble
and I would be one of them
if that would help you, or more
accurately, if that
would make me feel better.
I have never been noble
when it comes to the subject of you,
or at least, it's been years.
I've been reading my old notebooks
and I see I've let you get under my skin
for a long time. No fault
of yours, of course. You are
living along day to day, like me,
each on our own bicycle and not
putting boulders into the other's way,
but irritated, just the same, for any
forward motion the other is making
over there on that parallel path.
Q: How do we get along with others?
A: There are no others.
You see the impossible distance I have to go.
Keep pedaling, keep your knees churning, keep,
as much as you can, your eyes on the road,
and I'll do the same.

Talking to Myself as I Drive
to the Coffeehouse

I explain how I was reasonable
and the other guy nothing but cruel.
I make my closing argument, irrefutable,
I am Logic personified, given hands,
a wheel, a car. I hurtle the intersection,
take a right automatically. Who's
driving when I'm in the pulpit,
on my soapbox, blameless, innocent?
The car drives itself and brings me,
exonerated, to a parking space,
the carriage door opens, and I
alight, a citizen, a favorite, having
explained myself to myself
to everyone's satisfaction.
So deserving, so bold, I ask:
may I—I implore the barista
in her robes of justice,
looking up from the flower
she's drawing on my double-shot
whole milk peppermint latte—
I'm pointing my guiltless index finger
toward the top shelf of the case,
certain the answer is yes—
could I also have the blueberry Danish?

As Soon as I Smashed It

I began to fix it. I got
a bag of frozen peas
and held that on my
finger, the pinky; it bled
a little. I held it above my
head and walked around
in the rooms of my house.
I took an ibuprofen and
I thought *I need food with
this pill, not much in the
cupboard, what do I have?*
I had some little squares
of cereal. I ate a handful.
I chewed. It was old but
still OK. I thought of Reiki.
I texted my friend: *Please
send Reiki.* She texted: *Sending.*
I felt like receiving. The blood
felt tacky on the bag of frozen peas.
I arranged myself on my bed,
I propped my hand up, the hand
on the peas, the peas on a towel,
the towel on a pillow, the house
on the earth, the earth in the dark,
turning, a dancer on her toes,
twirling, coming around and around,
doing what she did, doing what she
does, doing what she will do.

I Tell My True Love about
the Bluebird of Happiness

She sat waiting on a low branch
over the trail and when I got
close, she opened her wings
and dangled in the air
so I wouldn't miss how
brilliant, how blue; she made
sure I saw. It was blinding.
You don't believe this kind of omen
unless it's right in front of your face,
as she made sure she was. Then
she disappeared, went on with her day,
and so did I, thinking *azure*, thinking *sky*,
thinking the sky's the limit, thinking
how I was going to tell you,
as now I am. You and I, Babe,
will weather the storm; we will
come through just fine. Get a lift
from the tailwinds, Babe, and migrate
on over to my place. Say you will,
say it with your hand over your heart,
heart like a bird fluttering, like truth
pumping. See what you've been
waiting for as it comes down the trail
toward you, and in a heartbeat
take a chance, leap into whatever
thin air. Show your cerulean. Things
will work out for us; it's you and me,
Babe, you and me.

Where the Fox Is

Where the fox is
I don't know

but I hope she
rests where she can see

trouble before
it sees her, looking out

through cover as the day comes on.
I remember how she crossed my yard,

crows above her head,
circling with their ruckus.

The fox focused forward, paid
no attention. I will learn:

last night all that fuss—words, words,
crows. Wear it like a halo. It's only noise.

Horses, Free

Open the doors of the barns
and follow the horses out into the world,
follow the hollow tapping of their hooves,
and see the streets their great hearts find
to amble in,
and which gate they will come
back to, like me,
for food and touch.

I choose
the building, house, tent,
where you and I
stand together,
the enclosure where we face,
or turn our backs,
where we give small things,
some visible,
one to the other.

The Things of this World

To say *the things of this world*
implies another,
as though we know a world,
all of it we can,
and we think maybe
there's at least one other.
The birds begin
a chipping. They aren't singing
to the sun; it's not up yet.
The trees stand all night
all their lives. Soft unseen
grass, and the owl. Air with its scent
and its passion to keep moving.
The dog tirelessly licking my hand.
The houses and commerce
my species has placed in patterns,
windows dark or lit.
I see how easy it would be
to make a noise
to the things of this world,
to sing a small chorus
in whatever language comes
to the throat.

When Life Seems a To-Do List

When the squares of the week fill
with *musts* and *shoulds*,

when I swim in the heaviness of it,
the headlines, the fear and hate,

then with luck, something like a slice of moon
will arrive clean as a bone

and beside it on that dark slate
a star will lodge near the cusp

and with luck I will have you
to see it with, the two of us,

fools stepping out the backdoor
in our pajamas.

Is that Venus?—I think so—Let's
call it Venus, cuddling up to the moon

and there are stars further away
sending out rays that will not

reach us in our lifetimes
but we are choosing, before the chaos

starts up again,
to stand in this particular light.

Acknowledgements

"Her Brown Horse Must Rise from the Dead" appeared in *Bosque*

"When I'm Reading Late" appeared in *Chattahoochee Review*

"The Nobody Bird" and "In the Dark Times, Will There Be Singing?" appeared in *Heartland*

"Each Wrong Choice Was a Horse I Saddled" appeared in *I-70 Review*

"What I Think My Real Self Likes" appeared in *Mud Season*

"Ah, Charles, If You Could Have" appeared in *Poetry East*

"Horses, Free" and "The Things of this World" appeared in *Poet Lore*

"Final Shirt" appeared in *Rattle*

"There's a Door in this World" appeared in *terrain.org*

The following poems were published in *Fourth River* as winner of their 2017 Folio contest:

"Despair Wakes Me"

"Hamburgers, Frying"

"I Don't Know Which River I Am"

"I Put Off Apology, Mother"

"My Mother the Child"

"She Didn't Want Another Dog"

"She Went to the Fair"

"This Is Her Territory, Not Mine"

"We Searched Our Mother's House for Money"

"What I Learned from My Mother"

CPSIA information can be obtained
at www.ICGtesting.com
Printed in the USA
FSHW02n1633210718
50500FS